CALLIGRAPHIES OF LOVE

Published 2017 by Saqi Books
2

Copyright © Hassan Massoudy 2017
Translation from French © Sophie Lewis 2017
Translation from Arabic © Elisabeth Jacquette 2017
Introduction © Saeb Eigner 2017

Design by Somar Kawkabi

978-0-86356-905-0

A full CIP record for this book is available from the British Library.

Printed by PBtisk s.a.

SAQI
26 Westbourne Grove, London W2 5RH
www.saqibooks.com

HASSAN MASSOUDY

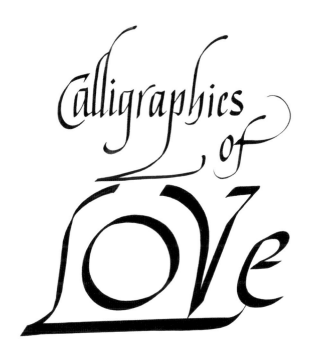

Calligraphies of Love

SAQI

INTRODUCTION

Hassan Massoudy was born and raised in the city of Najaf in central Iraq. As a young boy his mother would often take him on visits to her brother Ali's house. Hassan fondly recalls how fascinated he was upon entering his uncle's library of manuscripts, seeing him cross-legged on the floor quietly practicing the art of calligraphy. Hassan had not yet learned to read and write, but remembers his excitement in seeing the 'fluidity of the black ink on a smooth yellowy paper'.[1] From his childhood in Najaf, Hassan also recalls his visits to the textile souk; its many colours in sheer contrast to the ochre tone of his desert city. He would walk there with his mother whom, he recollects, often spoke to him using proverbs and short literary quotes.

Anyone that has visited Hassan's studio, along Paris' river Seine on the Quai de la Marne, cannot but sense the influence those early years have had on him. The walls of his atelier are adorned with beautiful calligraphic compositions, in colour and in black and white, based on short phrases that he has collected from around the world. The words are in Arabic and often translated into French, and include poetry, quotes by celebrated literary figures as well as proverbs and words of popular wisdom as his mother might have used. One word is picked out and sits at the centre of each composition, while the phrase in its entirety is beautifully written below, mainly in a script reminiscent of traditional Kufic. The studio is clean and orderly, and the overall atmosphere is one of serenity,

installing a sense of calm in all those who visit. For an art trove it is surprisingly welcoming – one could just imagine being greeted by the line 'Enter in peace and without fear'[2] as was written in Thuluth script above the door of his Uncle Ali's room.

During his early years in Najaf, it was a school teacher, and later Hassan's father, who recognised his beautiful handwriting, giving him the confidence and opportunity to develop his skill. His father would often ask Hassan to write the labels on goods destined to be exported, which he did with great enthusiasm. When he ran out of ink Hassan would hurry himself to the pigment shop which was filled with jars of natural pigments, each displaying beautiful handwritten labels giving its name and use. He recalls how these rows of colourful jars would plunge him into long reveries. A similar scene has been recreated in his Parisian atelier, where behind his desk a wall is dedicated to shelves of natural pigments.

As Hassan grew older, he was fortunate enough to meet a number of professional calligraphers and, in 1961, he moved to Baghdad to start work as an apprentice calligrapher. He would go on to set up his own studio while studying graphic design and fine arts. However, in 1969, in the midst of his country's political unrest, Hassan moved to Paris and joined the Ecole Nationale Supérieure des Beaux Arts. It was here that he developed his interest in Western art history and practices, and explored new techniques and media, mainly oil and acrylic on canvas. These forays into Western practices failed to satisfy Hassan: he was still drawn to his own heritage as well as the calligraphic practice. He knew traditional calligraphy alone would not allow the expression he so longed for thus started mixing figuration and script on canvases, aiming to combine his interest in Western art with his calligrapher's background. He was struggling to find his way when he came across Japanese calligraphers working with large brushes. He noted:

Two things differed from the calligraphy I knew: the use of huge brushes, while standing on the paper itself, to produce characters as large as a man's body; and the speed at which they worked, with rapid strokes giving expression to the calligrapher's intense emotions.[3]

The freedom of movement and, very importantly, the ability to give 'expression to the calligrapher's … emotions' became key to Hassan's work, allowing him to develop the distinctive Massoudy style as we know it today. Whether considering calligraphy or art, one aspect that appears to have always preoccupied Hassan is his desire to reach out to people. In the 1960s in Baghdad he had been struck by Iraqi artist Jawad Salim's monument Nasb Al Hurriya (The Monument for Freedom) commissioned in 1958 to mark the end of the country's monarchy and to celebrate the unity of its people. He found the monument very powerful and said, 'When I saw the power to persuade of his Monument, I knew I wanted to become an artist and study in Paris, like Jawad Salim.'[4]

In his biography, he also recalls that later, when at the Beaux Arts, he and his fellow students 'were keen to reintroduce art into the city away from commercial considerations. We sought art which would touch the hearts of the spectators.'[5]

Hence we come to the subject of this collection, 'love'. In both life and art, Hassan is a generous person whose main concern has always been to give and share with others. At the Beaux Arts his actor and director friend Guy Jacquet, fond of the Arabic language and poetry, suggested they work together on a performance. They produced the show *Arabesque*, which combined music and poetry with calligraphies written live and projected onto a large screen. The show was a huge success and was performed across France

and Europe over a period of thirteen years. This was a wonderful opportunity for Hassan, enabling him to combine his love of calligraphy and expression, while also engaging with a public. He said:

> Sometimes on stage, as I'm following the movements and melodies of my fellow performers, writing dynamically in black ink on a bright screen, I feel as though I'm sculpting an abstract shape that forms, dissolves and re-forms beneath my reactive hands. What word I'm trying to write … it might be 'Liberty', or 'Hope' or 'Peace' but I know that everyone watching the dance, who hears the music and observes that abstract, forming word, understands intuitively that whatever I'm shaping … is written in the common language of the human heart.[6]

The works presented in the following pages include many different proverbs and poems about love. They range from Roman poets Virgil (70 BC–19 BC) and Martial (circa 38/41 AD–102/104 AD) to modern and contemporary literary figures such as Iraqi Badr Shakir Al Sayyab (1926–1964), surrealist poet Paul Eluard (1895–1952) and French René Char (1907–1988). There are words of wisdom from celebrated Arab and Iranian authors dating from the eighth to the thirteenth centuries, a period often referred to as the 'Golden Age' of the Islamic world, as well as many other poems from countries and continents spanning India, America, Europe and Africa. Like many today, Hassan is deeply moved when hearing news of his homeland – he struggles to make sense of the ongoing troubles in Iraq and the wider region. When asked about his choice of subject for this book, he said that he enjoys working with quotes

on love from all corners of the globe, mainly 'to go against all ideas of intolerance and violence widespread in the world today.' Today more than ever, we need Hassan's work for it shows us the beauty of tolerance written by the hand of this master artist calligrapher of the world.

Saeb Eigner
London, 2017

NOTES

1. Translation from *Désir d'Envol Une Vie en Calligraphie*, p. 6.
2. Ibid.
3. The Abu Dhabi Festival, *ADMAF*, 2012, Interview with Gerard Houghton, p. 15.
4. Ibid, p. 8.
5. Hassan Massoudy, *Si Loin de l'Euphrate*, 2004, Editions Albin Michel, p. 159.
6. The Abu Dhabi Festival, *ADMAF*, 2012, Interview with Gerard Houghton, p. 20.

I saw that the eye was a window to the heart.

Al-Buhturi (9th century)

ولكني رأيت العين بابا الى القلب.

البحتري ـ القرن التاسع

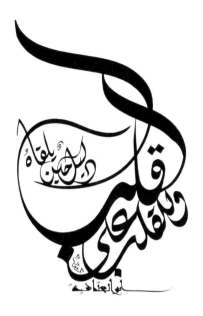

The heart guides the heart as soon
as they meet.

Abu Al-Atahiya (8th century)

وللقلب على القلب دليل حين يلقاه.

أبو العتاهية ـ القرن الثامن

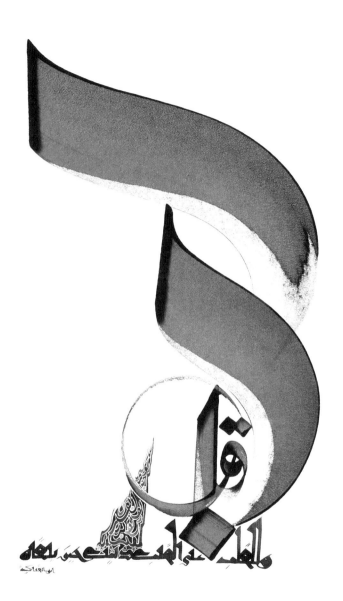

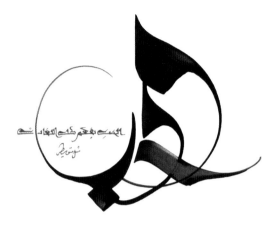

Love understands all languages.
Mediterranean proverb

الحب يفهم كل اللغات.
مثل متوسطي

When love comes in, reason flies the scene.
Reason cannot co-exist with love's madness;
Love has nothing to do with common sense.
Farid Al Din Attar (1145–1220)

عندما يأتي الحب، يهرب العقل بسرعة.
فريد الدين عطار

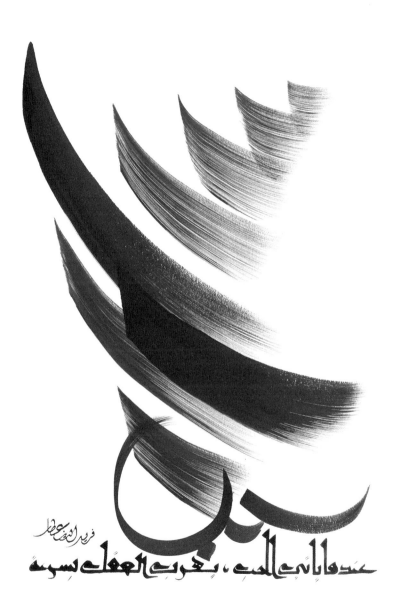

عندما تأتي الحياة ، بخير الحظ يسمه

فريد الدين عطار

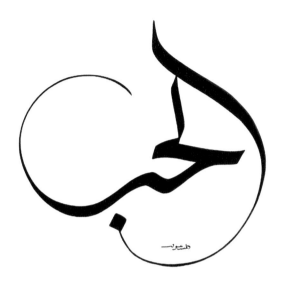

Love

الحب

Where there is love there is life.
Gandhi (1869–1948)

اين يوجد الحب توجد الحياة.
غاندي

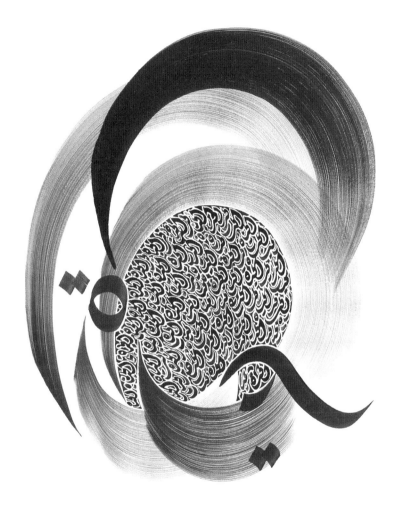

Love ▸

الحب

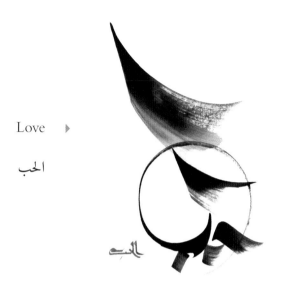

When love beckons to you, follow him,
Though his ways are hard and steep.
And when his wings enfold you yield to him,
Though the sword hidden among his pinions may
wound you.
And when he speaks to you believe in him,
Though his voice may shatter your dreams as the
north wind lays waste the garden.

Kahlil Gibran (1883–1931)

عندما يشير لكم الحب، اتبعوه، حتى لو تكن دروبه صلبة ووعرة.
جبران

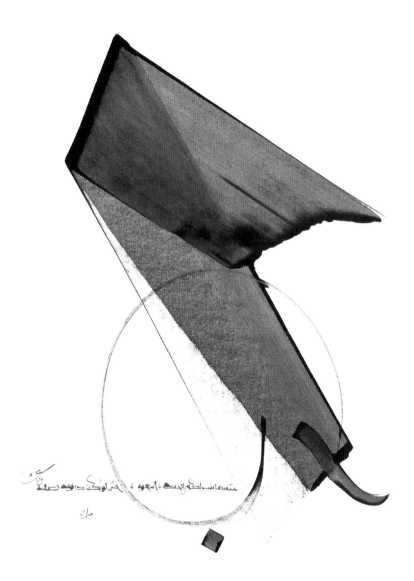

When you glanced at me, I learned
the meaning of love.

Ibn Zaydoun (11th century)

فهمت معنى الهوى من وحي طرفك لي.

ابن زيدون ـ القرن الحادي عشر

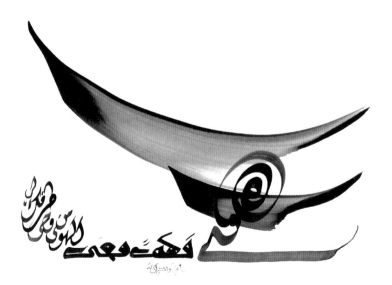

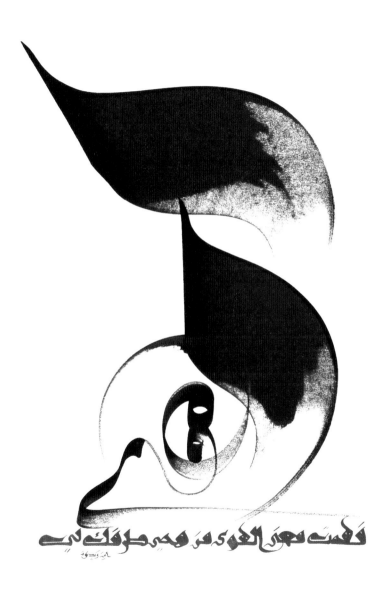

نقشت معنى القوة في حرف لك لي

احمد سعد

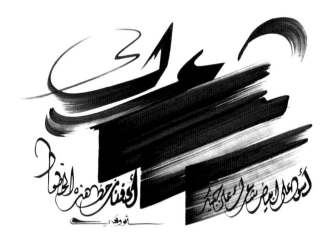

Black upon white: your curls upon your forehead.
Which artist could have penned such a calligraphy?

Kesaï (11th century)

اسود على ابيض : شعرك على جبينك. أي فنان خط هذه الخطوط.

قصي ـ القرن الحادي عشر

From every direction, the force of your
love makes my head spin.

Machrab (1657–1711)

من كل الجهات. نسيم حبك يفقدني صوابي.

مشرب ـ القرن الثامن عشر

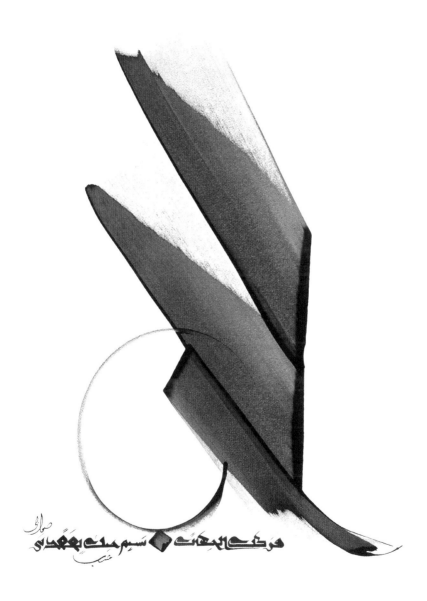

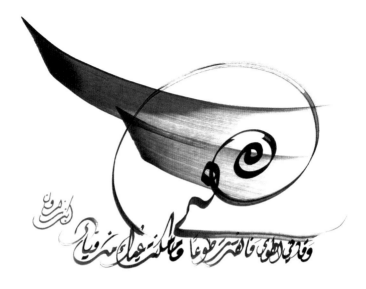

Love guided me and I followed it willingly.
No-one but you have I allowed to be my guide.

Ibn Zaydoun (11th century)

وقادني الهوى فأنقدت طوعا وما مكنت غيرك من قيادي.

ابن زيدون ـ القرن الحادي عشر

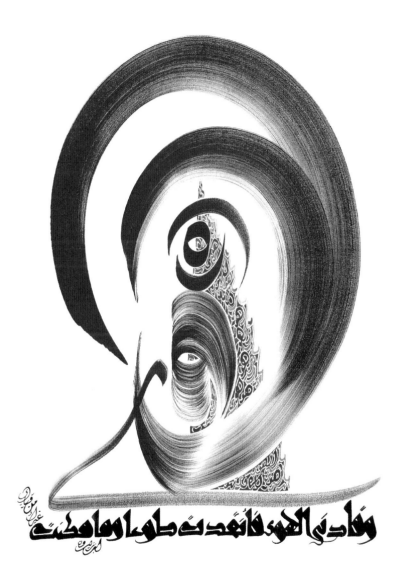

The heart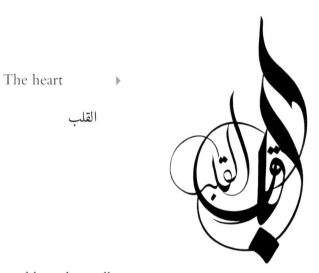

القلب

Yet I would not have all yet,
He that hath all can have no more,
And since my love doth every day admit
New growth, thou shouldst have new rewards in store;
Thou canst not every day give me thy heart,
If thou canst give it, then thou never gavest it:
Love's riddles are, that though thy heart depart,
It stays at home, and thou with losing savest it:
But we will have a way more liberal,
Than changing hearts, to join them, so we shall
Be one, and one another's all.

John Donne (1573–1631)

لتتصل قلوبنا، الواحد بالآخر، فنتحد في النهاية.
دون جون ـ القرن السابع عشر

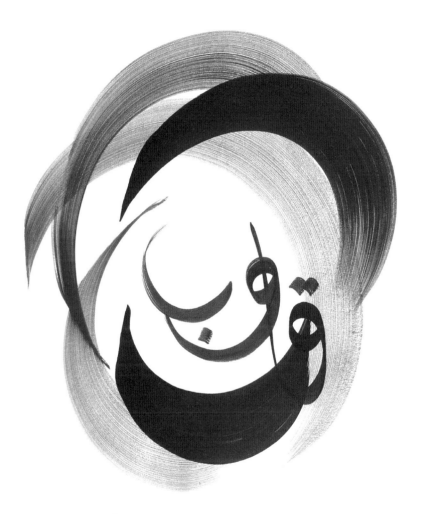

اتصلت قلوبنا الواحد بالآخر ، فشد بعضها بعضاً مودودون

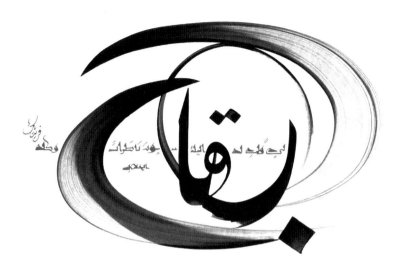

My heart has eyes only for you,
And is completely in your hands.
Al-Hallaj (10th century)

لي قلب له اليك عيون ناظرات وكله في يديك.
الحلاج ـ القرن العاشر

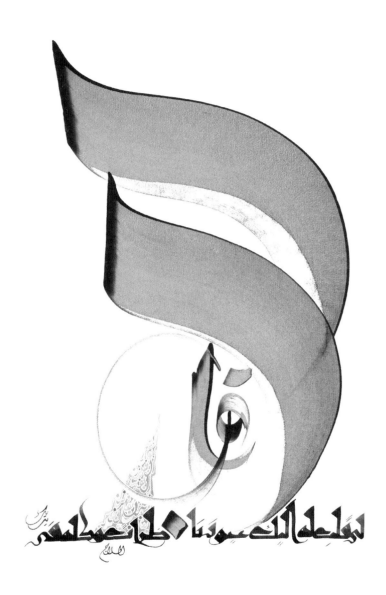

The measure of love is to love
without measure.

St Augustine (354–430)

الاعتدال في الحب هو الحب بلا اعتدال.

القديس اوغسطان ـ القرن الخامس

The eyes tell you about the heart.

Zouhair Ibn Abi Salma (7th century)

تخبرك العيون عن القلوب.

زهير بن ابي سلمى ـ القرن السابع

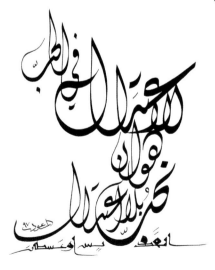

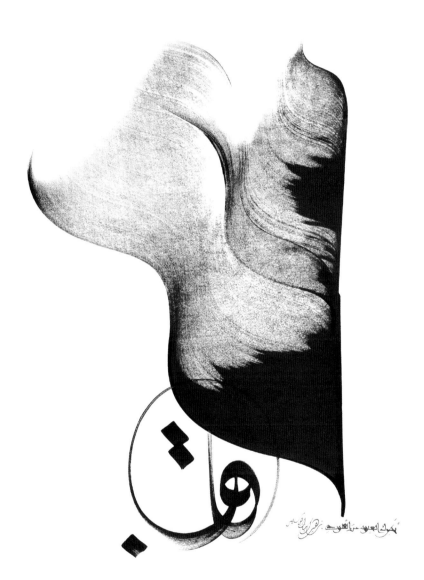

My heart has become able, to take on all forms.
It is pasture for gazelles; an abbey for monks.
It is a temple for idols, and for whoever circumambulates
it, the Kaaba.
It is the tablets of Turah, and also the leaves of the Koran.
I believe in the religion of love,
Whatever direction its caravans may take,
For love is my religion and my faith.

Ibn Arabi (13th century)

أُدين بدين الحب أنّى توجهت ركائبه فالحب ديني وايماني.
ابن عربي - القرن الثالث عشر

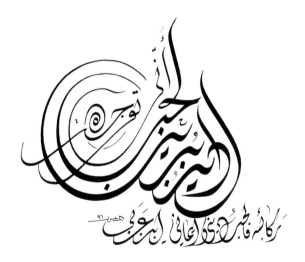

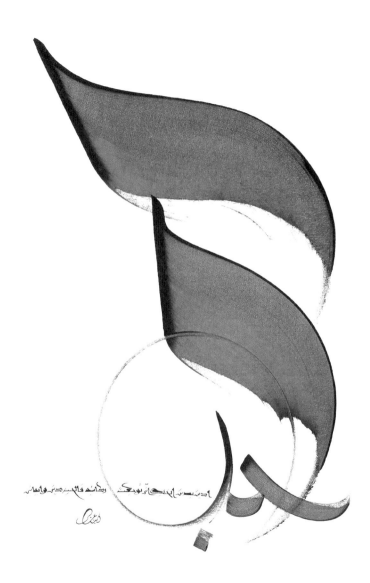

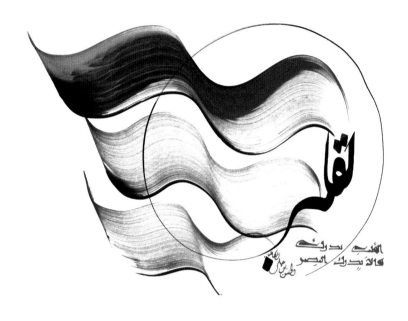

The heart perceives what sight cannot.
Al Hassan ibn Ali Al-Qadi (10th century)

القلب يدرك ما لايدرك البصر .
الحسن بن علي القاضي ـ القرن العاشر

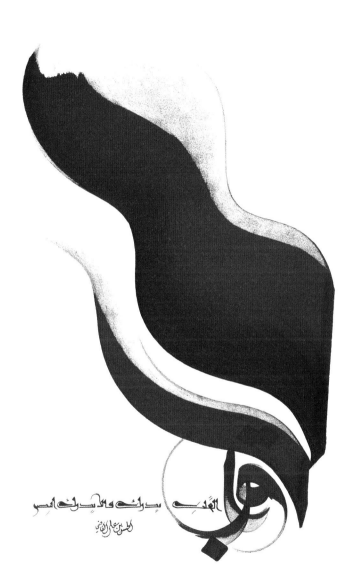

What did your eyes say to my
heart which made it reply so?

Al-Senoberi (10th century)

ما الذي قالته عيناك لقلبي فأجابا؟

الصّنوبري ـ القرن العاشر

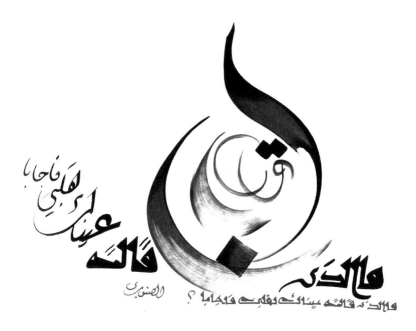

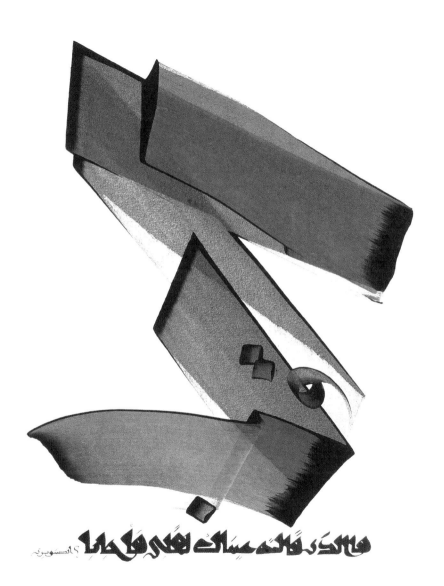

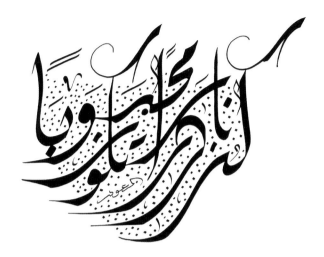

To be rare is to be loved.
Turkish proverb

كن نادرا ستكون محبوبا.

مثل تركي

You line your eyes with kohl so well
My passions are riled.
Antara ibn Shaddad (525–615)

لك من عبلة التكحل في العين كذا الجيد قد
اهاج غرامي.

عنترة بن شداد ـ القرن السابع

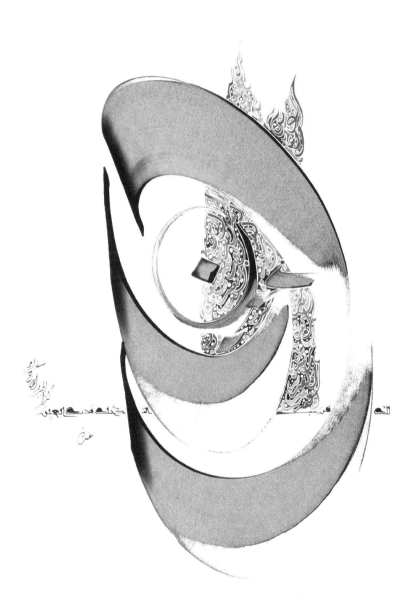

To be loved, love.

Martial (1st century)

لكي تُحب، حب.

مارسيال ـ القرن الاول

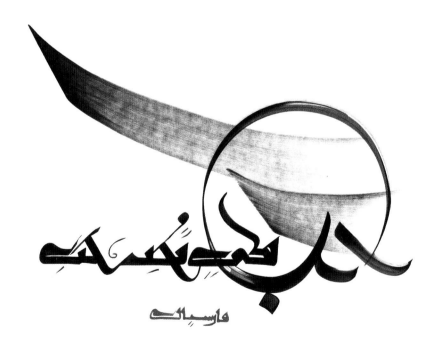

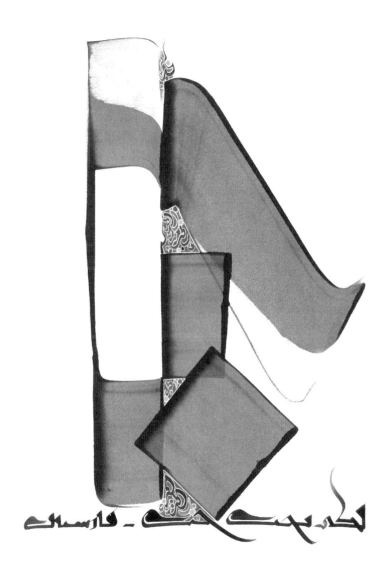

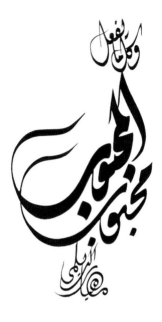

The beloved's every act is adored.
Mihyar al-Daylami (11th century)

وكل ما يفعل المحبوب محبوب.

مهيار الديلمي ـ القرن الحادي عشر

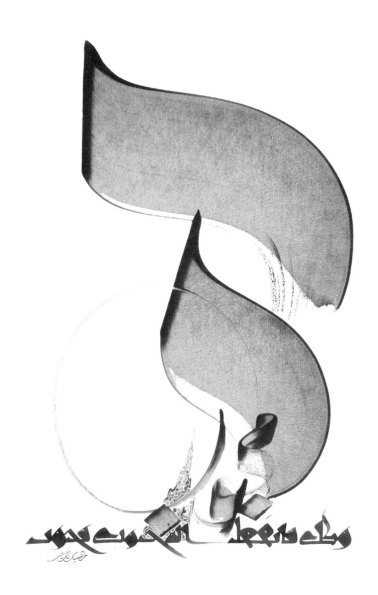

The heart

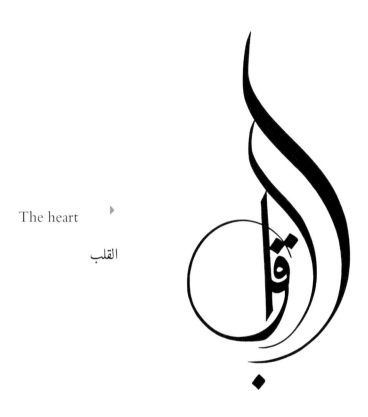

القلب

There's hope for all wounded to heal,
Save a wounded heart shot by her eyes.

Al-Mutanabbi (10th century)

كل جريح ترجى سلامته الا فؤادا رمته عيناها.

المتنبي ـ القرن العاشر

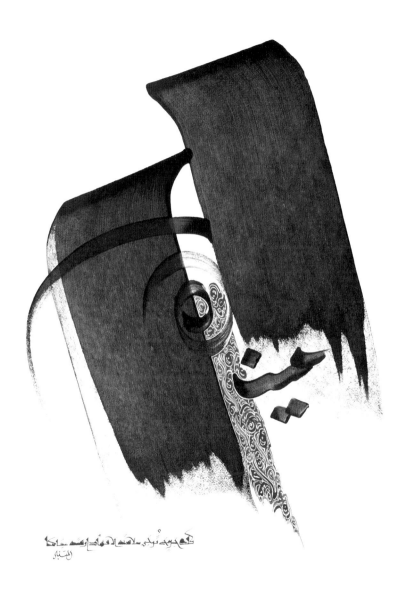

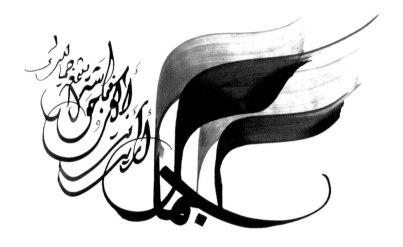

I wish to be a moth flitting
Around the candle of your beauty.
Machrab (1657–1711)

اريد ان أكون فراشة حول شمعة جمالك.
مشرب ـ القرن الثامن عشر

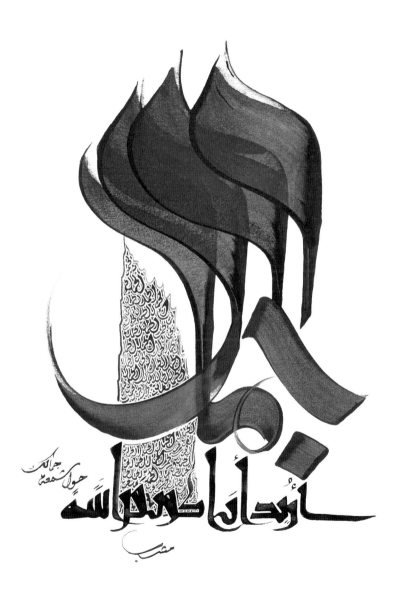

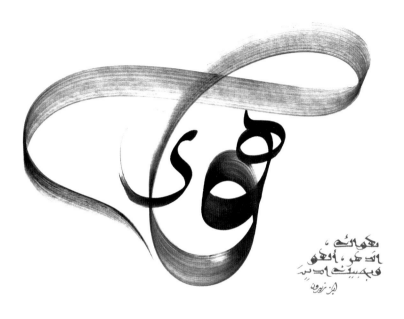

In your love, eternally, I delight.
To your love, I submit.

Ibn Zaydoun (11th century)

بهواك، الدهر، ألهو وبحبيك ادين.

ابن زيدون ـ القرن الحادي عشر

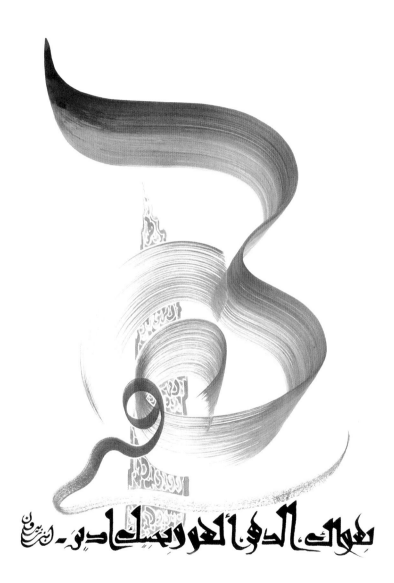

His soul is my soul, my soul is
his soul.
What he wants I want, what I
want he wants.

Al-Hallaj (10th century)

روحه روحي وروحي روحه ان يشا شئت
وان شئت يشا.

الحلاج ـ القرن العاشر

Old love does not lose its luster.

Mediterranean proverb

حب قديم لايفقد بريقه.
مثل متوسطي

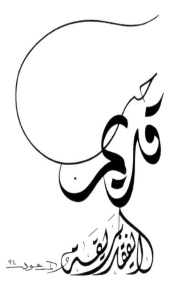

I am the one I love, and the one I love
is me, we are two souls in one body.
To see myself is to see him, and to see
him is to see us.

Al-Hallaj (10th century)

أنا من أهوى ومن أهوى أنا نحن روحان حللنا بدنا
فاذا أبصرتني ابصرته واذا ابصرته ابصرتنا.
الحلاج ـ القرن العاشر

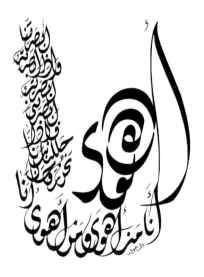

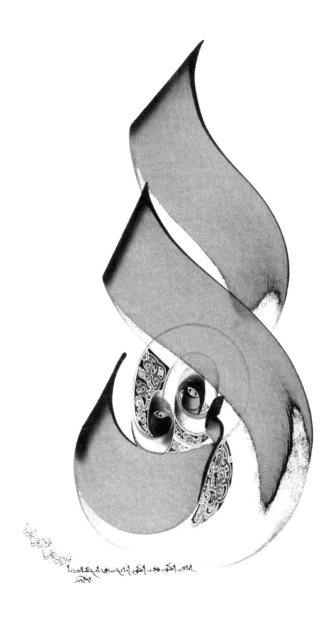

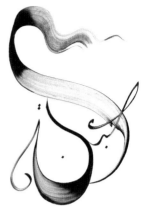

The sight of you satisfies my love.
You are the mistress of my heart,
You are the sovereign of my whole being.
Oh Abla, how to paint your portrait?

Antara ibn Shaddad (525–615)

صورتك تكفي لحبي، انت سيدة قلبي
وملكة وجودي
كيف أرسم صورتك ياعبلة.

عنترة بن شداد

The beauty you see in me is a
reflection of you.

Rumi (13th century)

الجمال الذي تراه عندي ما هو الا
انعكاس منك.

جلال الدين رومي ـ القرن الثالث عشر

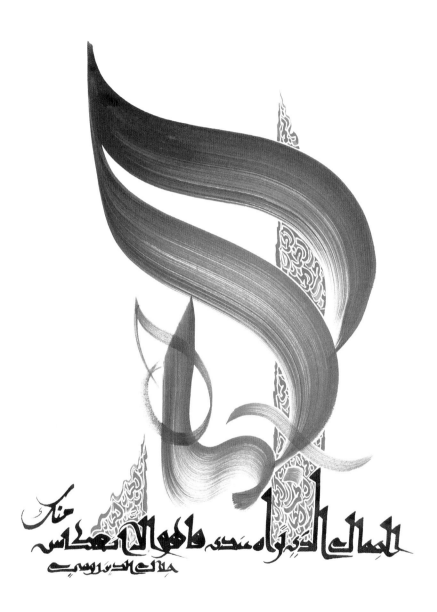

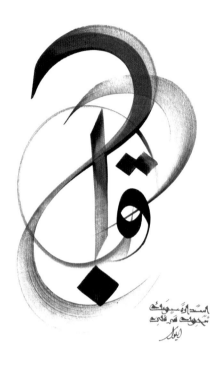

The curve of your eyes goes
around my heart.
Paul Eluard (1895–1952)

استدارة عيونك تتجول في قلبي.
بول اليوار ـ القرن العشرين

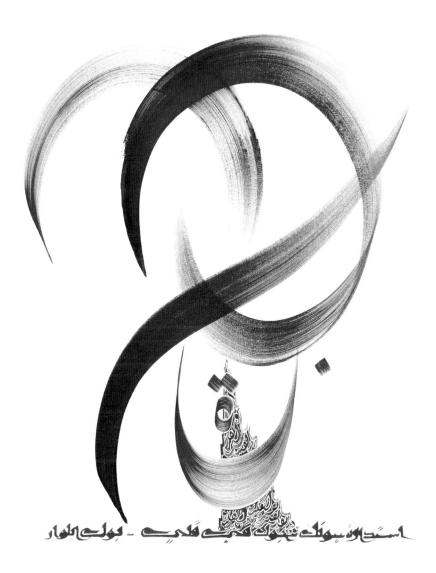

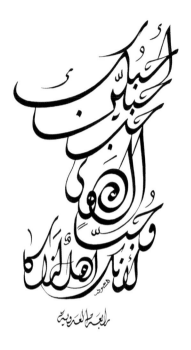

I love you with two kinds of love:
Passionate love, and the love you
deserve.

Rabia Al-Adawiyya (8th century)

احبك حبين : حب الهوى وحبا لانك
أهل لذاكا.

رابعة العدوية ـ القرن الثامن

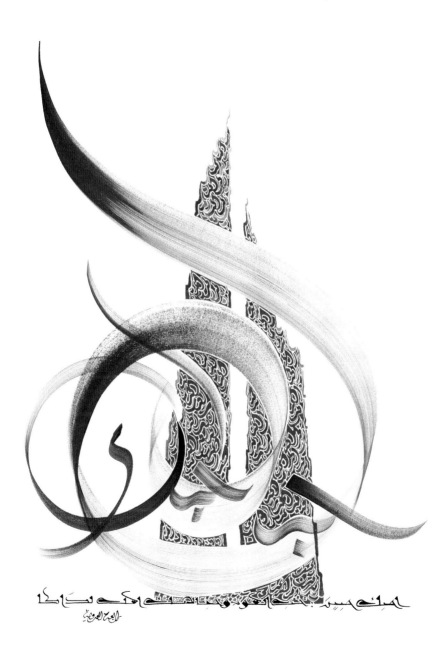

Love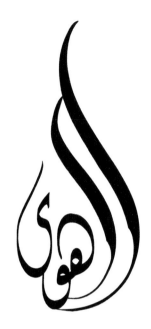

الهوى

Love guided me and I followed
it willingly.
No-one but you have I allowed
to be my guide.

Ibn Zaydoun (11th century)

وقادني الهوى فأنقدت طوعا وما مكنت
غيرك من قيادي.

ابن زيدون ـ القرن الحادي عشر

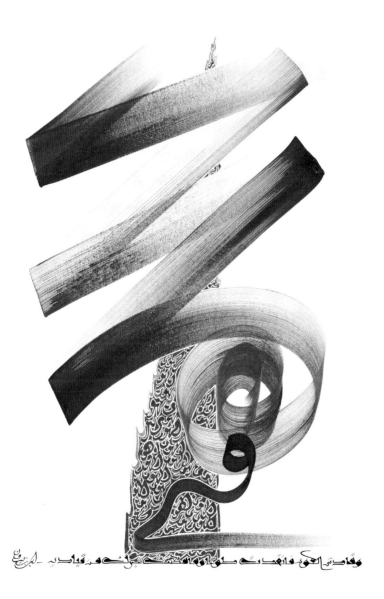

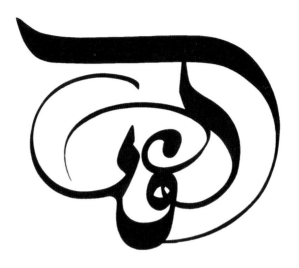

Love

الهوى

Can I say you are honey?
Honey is less sweet than you.
Nezami (12th century)

سأقول أنت عسل، لا ان العسل أقل
حلاوة منك.

نظامي ـ القرن الثاني عشر

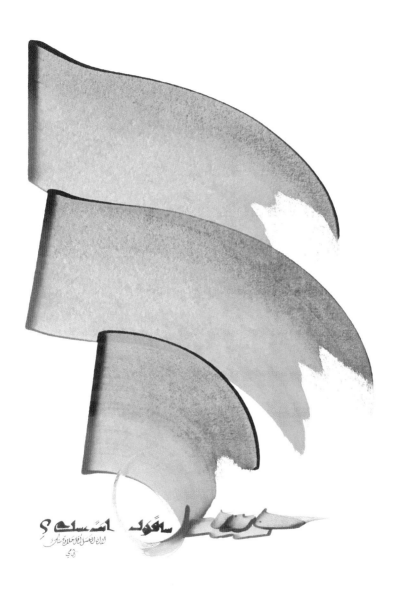

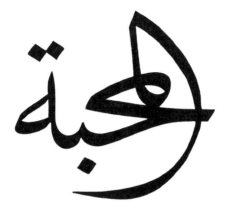

Love

المحبة

Nothing is more deeply moving
than a love that has grown in silence.
Goethe (1749–1832)

لاشيء أكثر تأثيرا من حب اتسع داخل الصمت.

جوته ـ القرن التاسع عشر

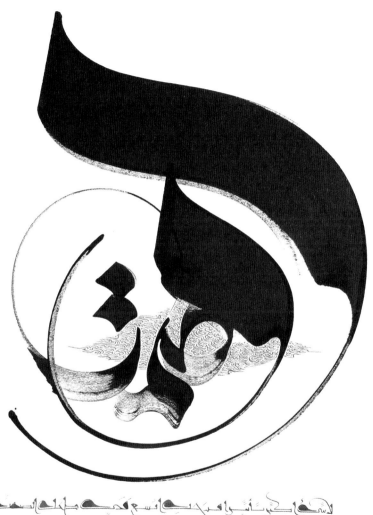

Love ▶

الحب

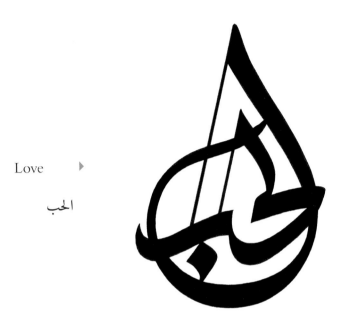

Love gives naught but itself and ▶
takes naught but from itself.
**Love possesses not nor would
it be possessed;
For love is sufficient unto love.**
Kahlil Gibran (1883–1931)

الحب لايملك ولا يمتلك، فالحب يكفيه
انه الحب.

جبران ـ القرن العشرين

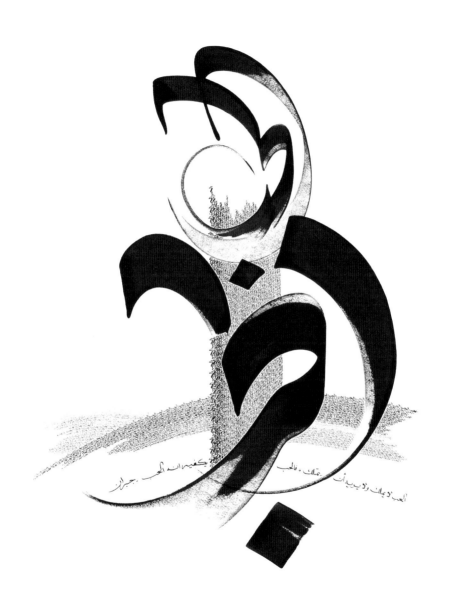

يكمله الله الحب جبران

عمك وطالب

الحب لا عطاك ولا يريدان

I almost wish we were butterflies and liv'd but three summer days,

three such days with you I could fill with more delight than fifty common years could ever contain.

John Keats (1795–1821)

أحلم ان نكون فراشات لاتملك زمنا للعيش الا ثلاثة أيام صيفية.

جون كيتس ـ القرن التاسع عشر

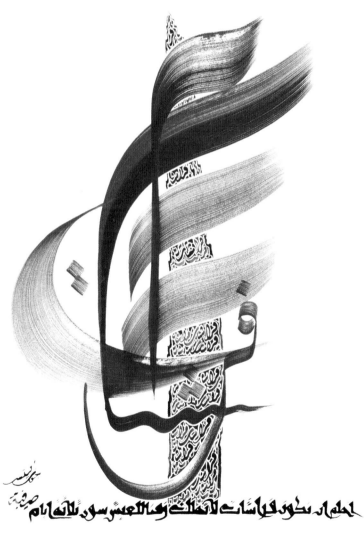

There is no remedy for love
but to love more.

Henry David Thoreau (1817–1862)

هنالك دواء واحد للحب: الحب أكثر.

هنري دافيد ثورو ـ القرن التاسع عشر

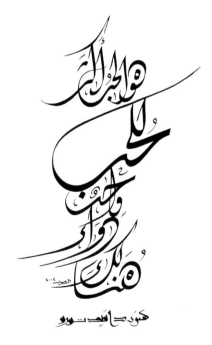

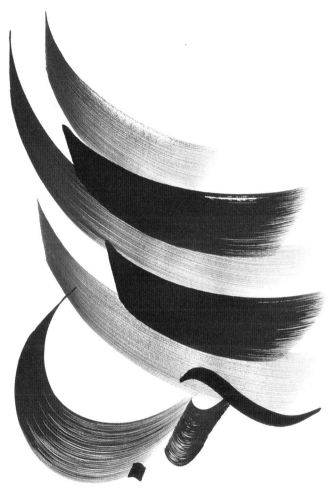

قالت علي ولمد لمحت الحمد أكو هنز دانيتفو

Through love, that which is
bitter becomes sweet.

Rumi (13th century)

الحب يجعل المر حلو.

جلال الدين رومي ـ القرن الثالث عشر

For those who love, time is
endless.

Mediterranean proverb.

لمن يحب الزمن هو ابدي.

مثل متوسطي

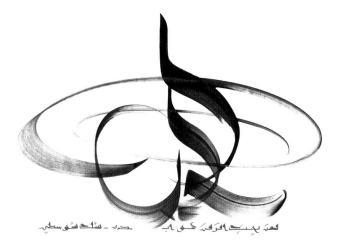

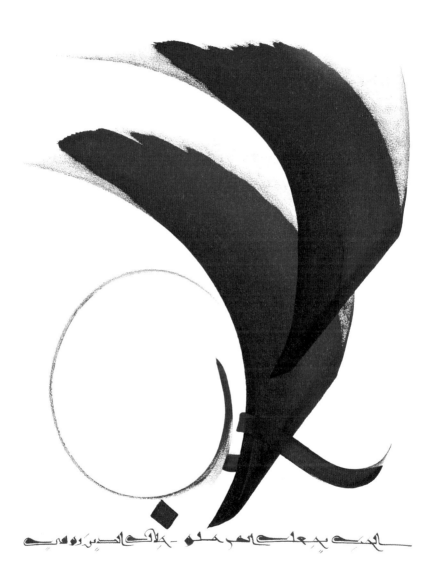

Love guided me and I followed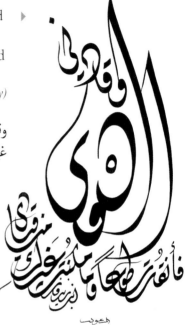
it willingly.
No-one but you have I allowed
to be my guide.

Ibn Zaydoun (11th century)

وقادني الهوى فأنقدت طوعا وما مكنت
غيرك من قيادي.

ابن زيدون ـ القرن الحادي عشر

Bow to nothing but love.
René Char (1907–1988)

لا تنحني الا للحب.

رينة شار ـ القرن العشرين

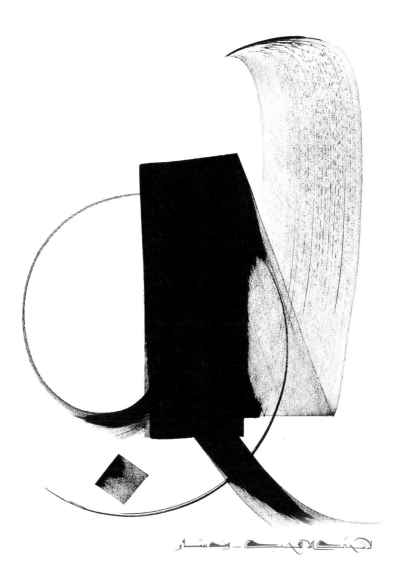

اشهد الحمد ـ يسار

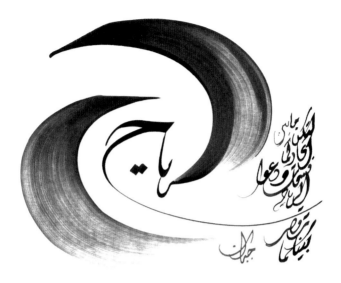

Let there be spaces in your togetherness.
And let the winds dance between you.
Love one another, but make not a bond of love:
Let it rather be a moving sea between the shores
of your souls.

Kahlil Gibran (1883–1931)

لتكن ما بين اتحادكما فسحات ودعوا
الرياح ترقص بينكما.

جبران ـ القرن العشرين

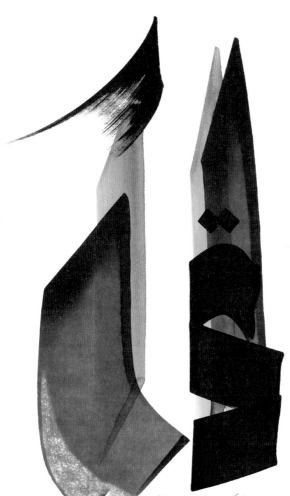

Where there is love, there is no
room for darkness.

Mediterranean proverb

حيث يوجد الحب لا مكان للظلام.

مثل متوسطي

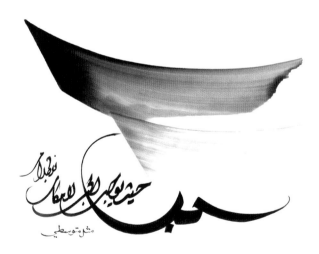

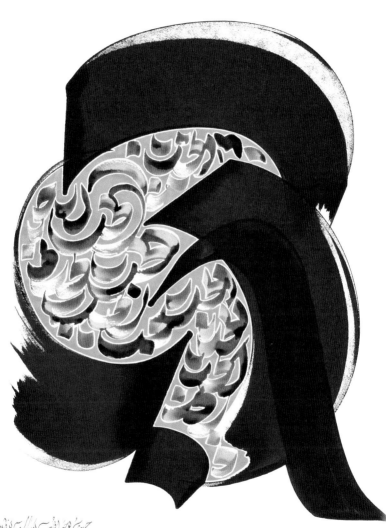

حسين في عبد القدس لا مكان للظلام يمكن أن يقهر النور الذي ينبثق

A woman is a ray of divine light.

Rumi (13th century)

المرأة هي اشعاع النور الآلهي.

جلال الدين رومي ـ القرن الثالث عشر

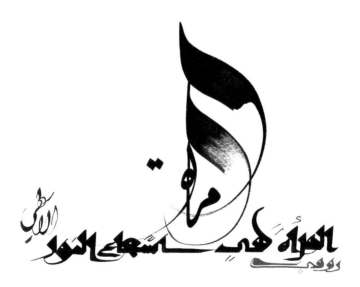

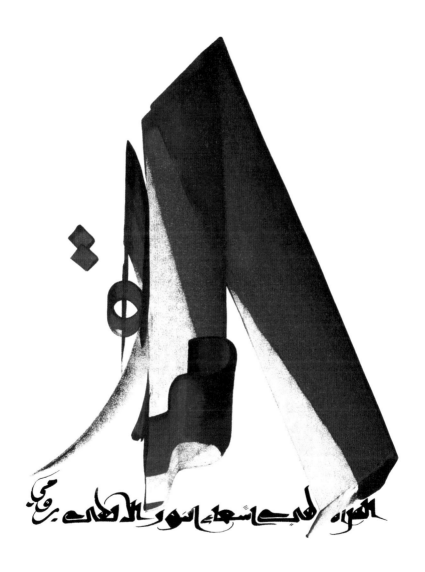

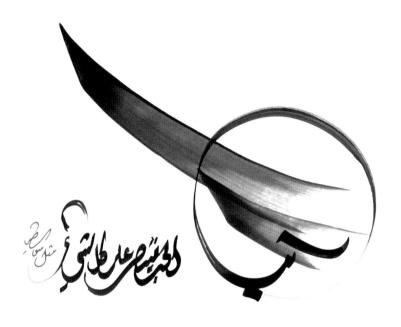

الحب ينتصر على كل شيء

Love conquers all.
Virgil (70–19 BCE)

الحب ينتصر على كل شيء.
فيرجيل ـ القرن الأول قبل الميلاد

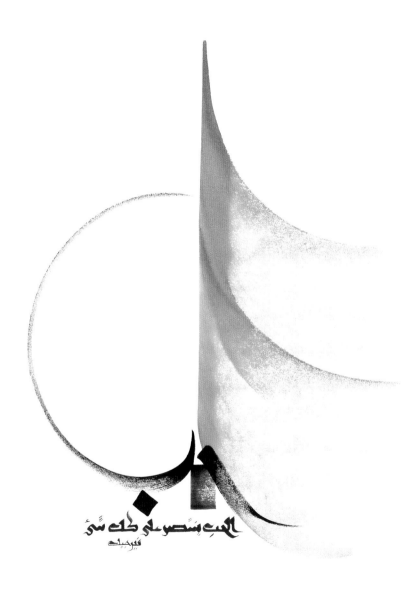

When you glanced at me,
I learned the meaning of love.

Ibn Zaydoun (11th century)

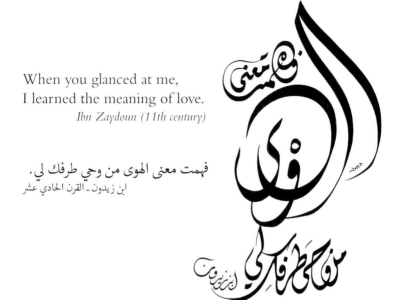

فهمت معنى الهوى من وحي طرفك لي .

ابن زيدون ـ القرن الحادي عشر

To love him worse, to love him better,
I demand what I must from my heart.

Areeb (797–890)

واني لأهواه مسيئا ومحسنا وأقضي على
قلبي بالذي يقضي .

عريب ـ القرن التاسع

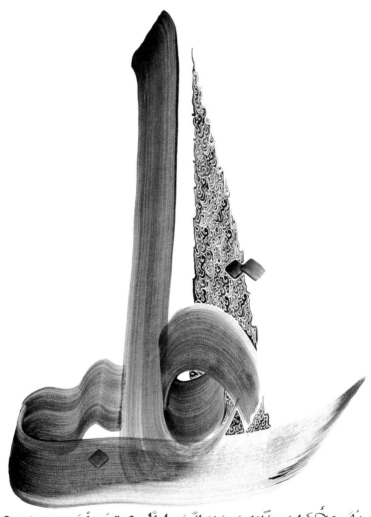

فَإِنْ لَمْ أُهْوَاهُ مُسِيئاً فَحُسْنَاهُ الْفُضْلَى عَلَى قَلْبِكَ الَّذِي يُعَصِّي ـ عَرَبِي

I've known love from the moment
I encountered your love.

Rabia Al-Adawiyya (8th century)

عرفت الهوى مذ عرفت هواك.

رابعة العدوية ـ القرن الثامن

The eyes speak more than the
mouth can say.

Abu Al-Atahiya (8th century)

وفي العين غنى للعين ان تنطق أفواه.

أبو العتاهية ـ القرن الثامن

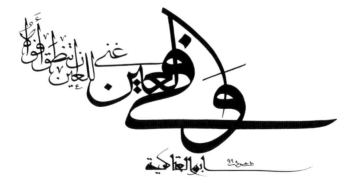

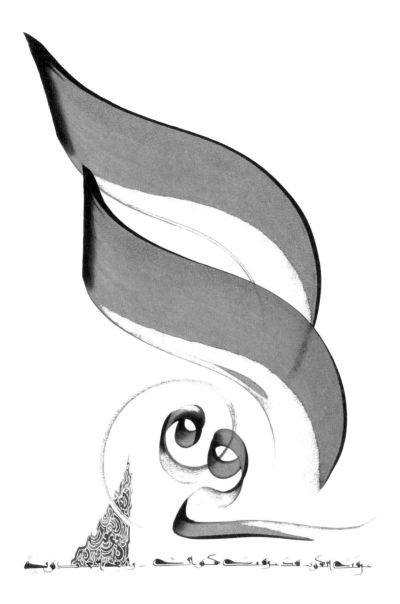

In your love, eternally, I delight.
To your love, I submit.
Ibn Zaydoun (11th century)

بهواك، الدهر، ألهو وبحبيك ادين.
ابن زيدون ـ القرن الحادي عشر

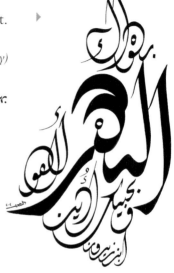

Even hiding you away in my eyes
for all time would not be enough.
Wiladda (11th century)

واني لو خبأتك في عيوني على طول
الزمان لما كفاني.
ولادة ـ القرن الحادي عشر

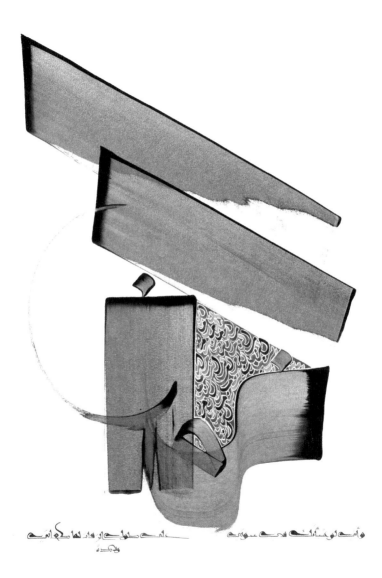

I vow not to forget him as long as I live,
And as long as night follows day.

Zeinab al-Dhabiyyah (7th century)

وأقسم لا انساه مادمت حية وما دام ليل
من نهار يعاقبه.

زينب الضبية ـ القرن السابع

When the days allow us
to meet, shall we then be
reunited?

Thousand and One Nights

متى الأيام تسمح بالتلاقي وتجمع شملنا بعد
الفراق.

من الف ليلة وليلة

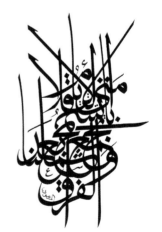

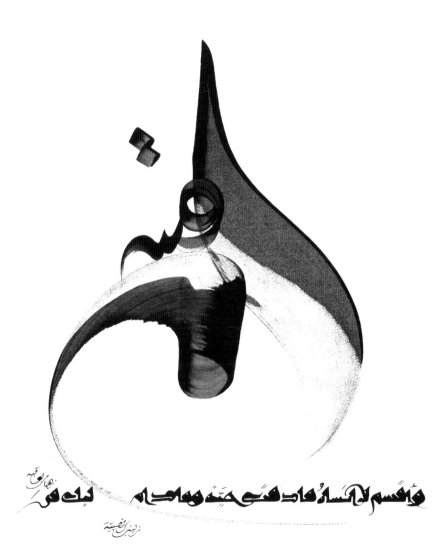

وأقسم لأنسان خالد في حبه وأحلامه لك قوة

من ديوان الحسنة

From how great my love for you,
my bewilderment grew.

Ibn Al-Faredh (13th century)

زدني بفرط الحب فيك تحيرا.

ابن الفارض ـ القرن الثالث عشر

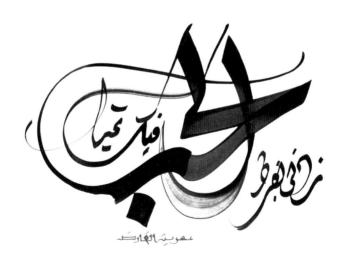

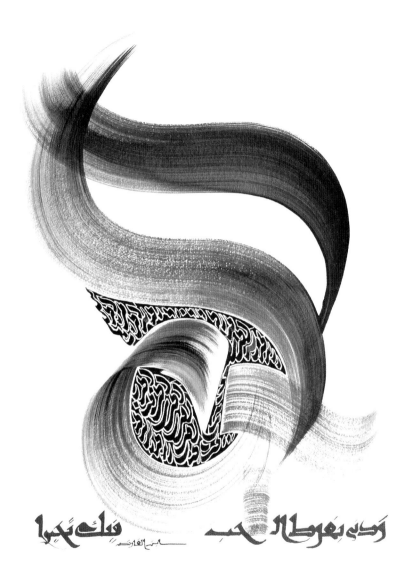

Your eyes, two dark palm groves just before dawn.
 Or two balconies, under a distant moon.

Badr Shaker Al-Sayyab (1927–1964)

عيناك غابتا نخيل ساعة السحر أو
شرفتان راح ينأى عنهما القمر .

بدر شاكر السياب ـ القرن العشرين

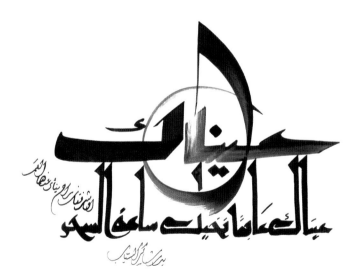

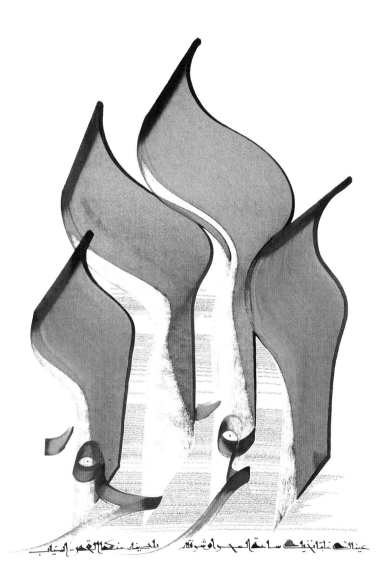

عينالك نباتابذيك سامعالسحراونرفشاه بلحينك منكالقمر - إيساب

Love knows not its own depth until the moment of parting.

Kahlil Gibran (1883–1931)

لايعرف الحب مدى عمقه الا في لحظة الفراق.

جبران ـ القرن العشرين

Love

الهوى

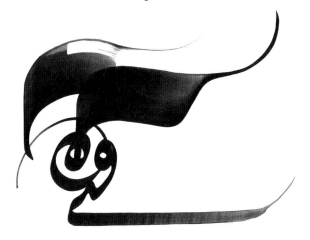

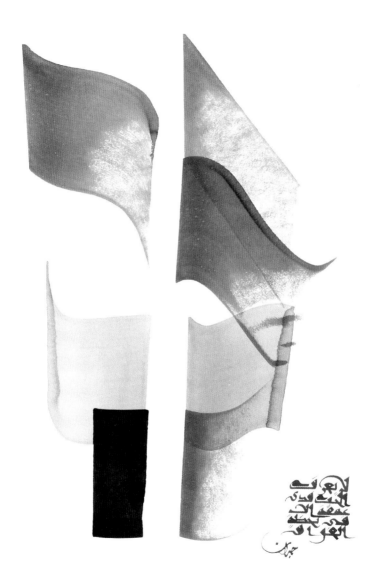

When I die for fear of
despair, hope restores me.
How often I have perished,
and then been revived.

Majnoun Layla (7th century)

اذا متّ خوف اليأس أحياني الرجا فكم
مرة قد متّ ثم حييت.

مجنون ليلى ـ القرن السابع

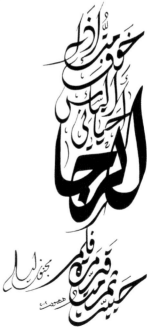

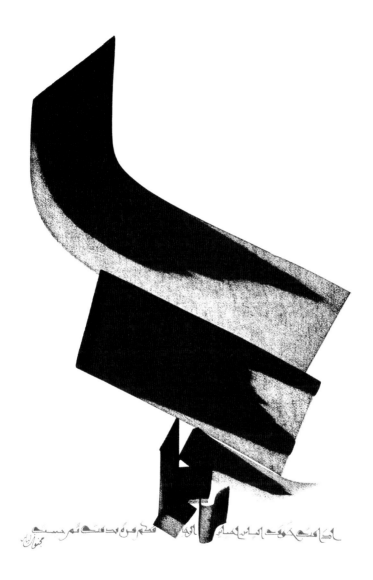

ا جا سے حروف اساس لہ ماہ اللہ فتم وہ بدسک لم حسی

بجنوان الہ

Nothing is real other than dreams and love.

Anna de Noailles (1876 – 1933)

لا شيء حقيقي الا الحلم والحب.

اتّا دو نواي ـ القرن العشرين

If you walk towards me,
I shall run towards you.

Rumi (13th century)

ان تقصدني ماشيا سأقصدك راكضا.

جلال الدين رومي ـ القرن الثالث عشر

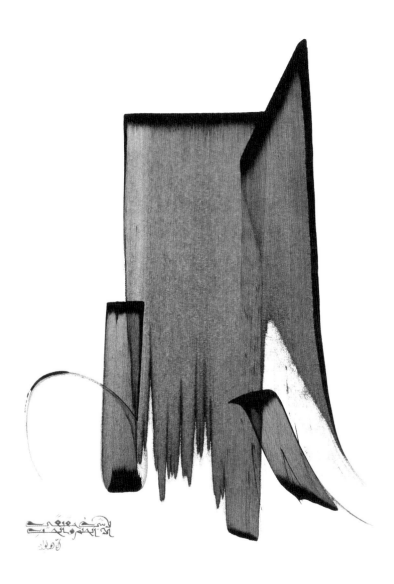

Oh absent ones, I see you within my heart.

Al Baha Zouhair (13th century)

يا غائبين وفي قلبي اشاهدهم.

البهاء زهير ـ القرن الثالث عشر

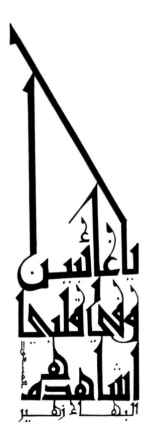

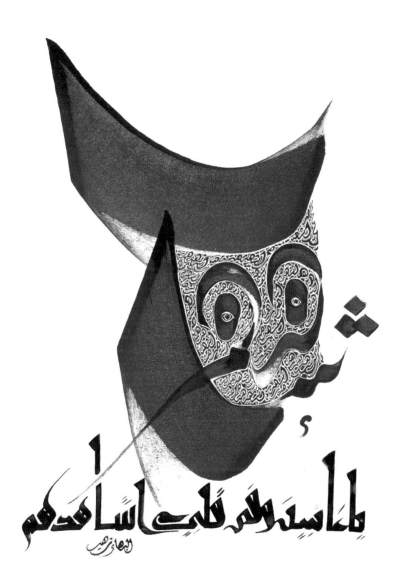

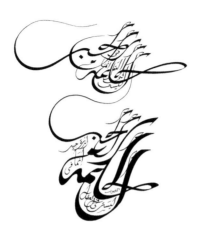

Wisdom lies not in reason but in love.

André Gide (1869 – 1951)

الحكمة ليست في العقل انما في الحب.

اندره جيد ـ القرن العشرين

He is parted from me and oh!
How my heart from him is parted.

'Ulayya bint al-Mahdi (777–825)

منفصل عني وما قلبي عنه منفصل.

علية بنت المهدي

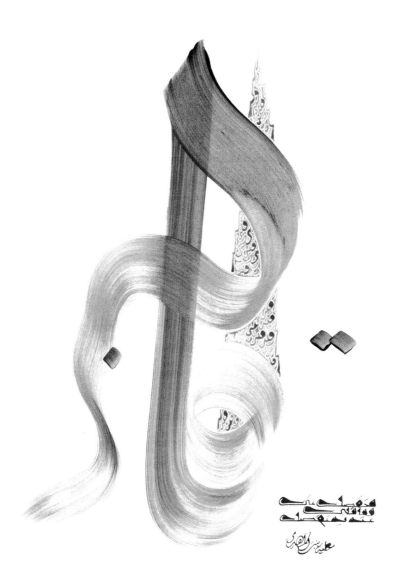

The measure of love is to love without measure.
St Augustine (354–430)

الاعتدال في الحب هو الحب بلا اعتدال.
القديس اوغسطان ـ القرن الخامس

A thousand, thousand welcomes
To women who glance not at me.
Bashar Ibn Burd (8th century)

يا مرحبا الفاً والفا بالكاسرات التي طرفا.
بشار بن برد ـ القرن الثامن

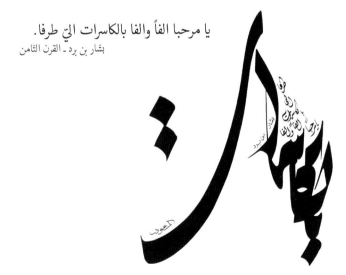

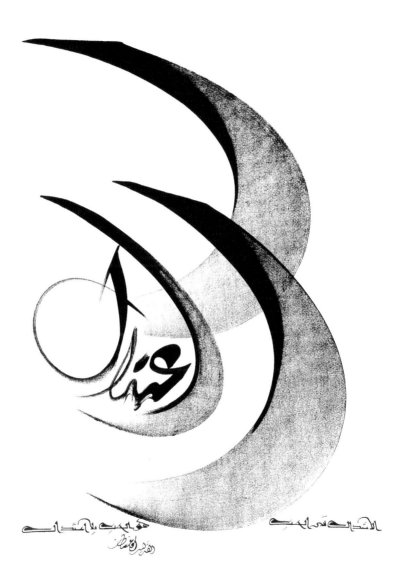

What have I done that was not out of love?

Ibn Al-Faredh (13th century)

ألا في سبيل الحب ما انا صانع ؟

ابن الفارض ـ القرن الثالث عشر

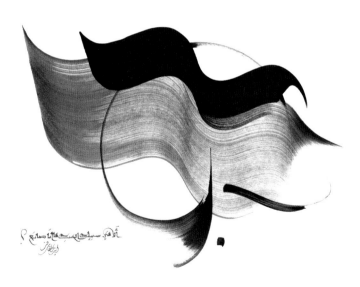

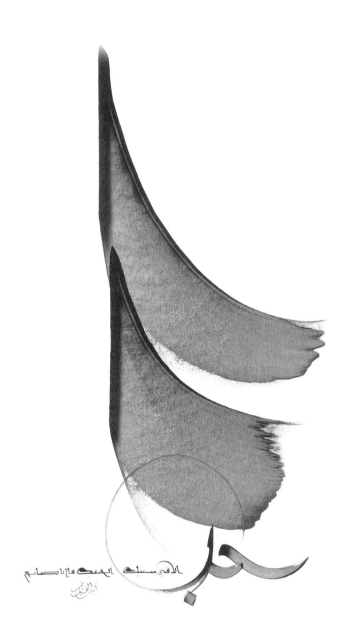

I was like an unfinished statue;
Love came and polished me,
and I became human.

Mohammed Iqbâl (1873–1938)

كنت كتمثال لامكتمل، جاء الحب
وصقلني فأصبحت انسانا.

محمد اقبال ـ القرن العشرين

The heart

القلب

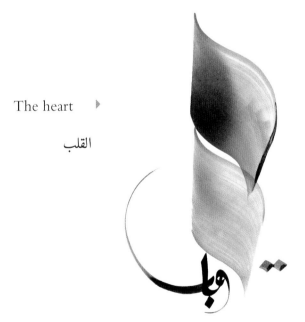

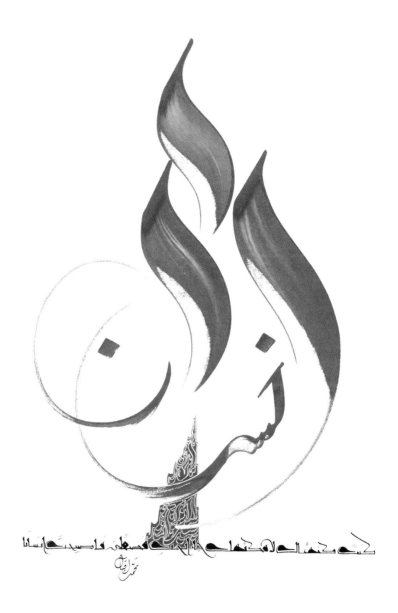

Where is there a musician to
interpret the emotions of my heart?

Orfi Shirazi (1555–1590)

أين أجد الموسيقي الذي سيترجم ارتجافات قلبي.

اورفي الشيرازي ـ القرن السادس عشر

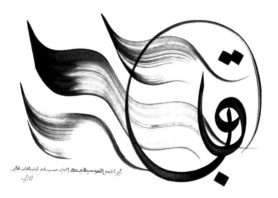

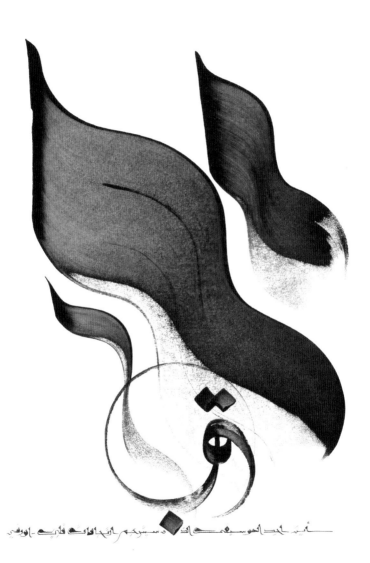

Will my eyes ever see those who I love?

Ibn Al-Faredh (13th century)

تُرى، مقلتي يوماً ترى من أحبهم؟

ابن الفارض ـ القرن الثالث عشر

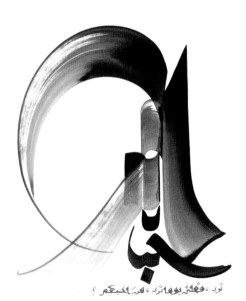

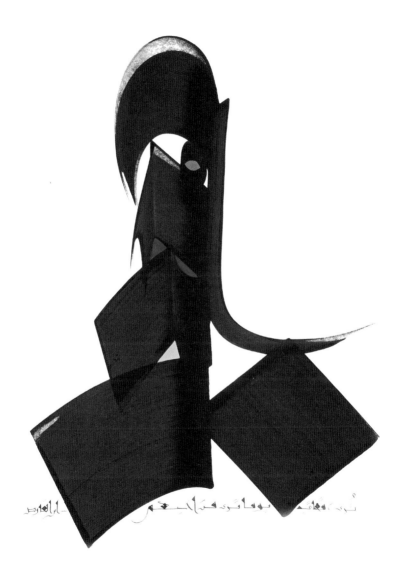

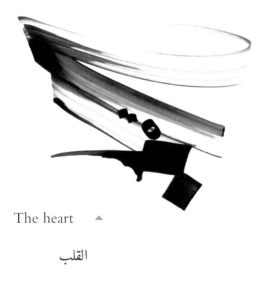

The heart ▲

القلب

I bemoan those who bade me taste their love,
Who after rousing me with passion, retired.

Abbas Ibn Al-Ahnaf (8th century)

أشكوا الذين أذاقوني محبتهم حتى اذا ايقظوني بالهوى رقدوا.
العباس بن الآحنف ـ القرن الثامن

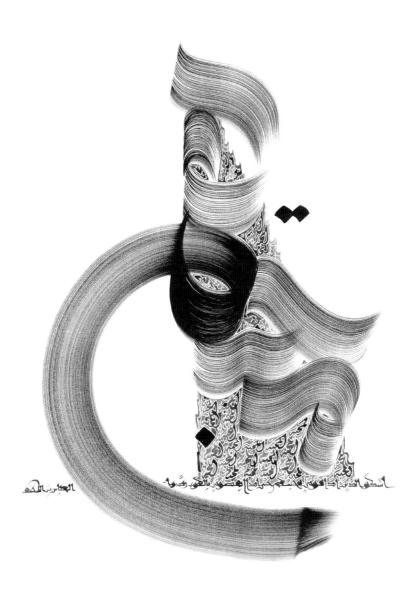

As long as there is love in your
heart, do not be saddened.

Mediterranean proverb

لا تحزن طالما في قلبك حب.

مثل متوسطي

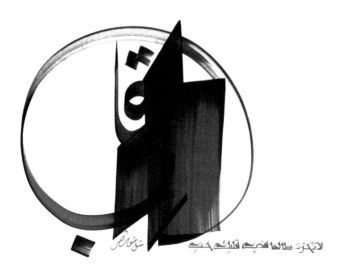

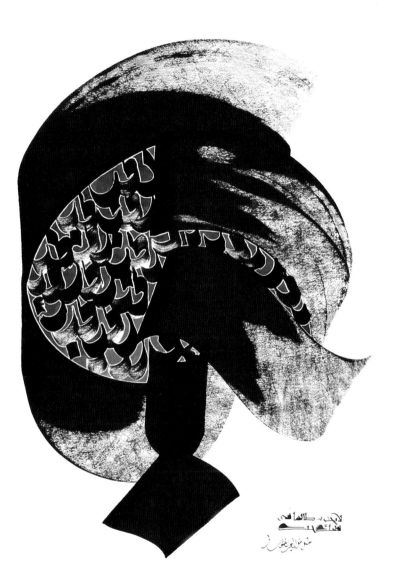

I drank glass after glass of love,
The drink has not run dry, nor is
my thirst sated.

Junayd (8th century)

شربت الحب كأسا بعد كأس فما نفد
الشراب وما رويت.

الجنيد ـ القرن الثامن

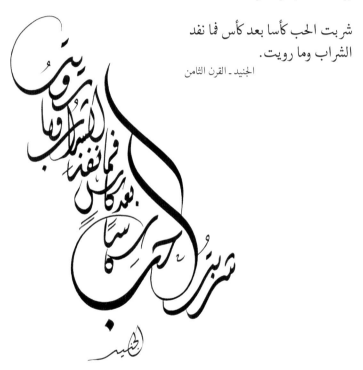

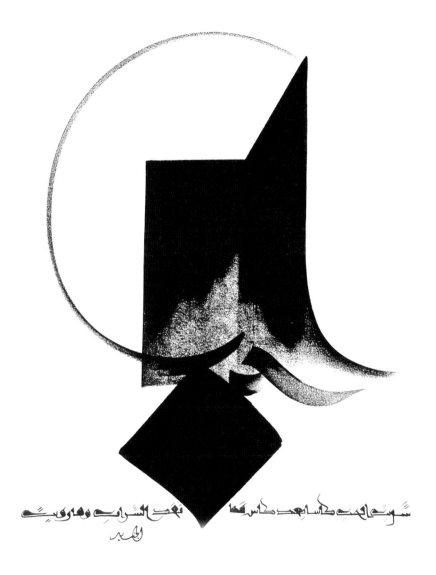

سورة المائدة آية ثلاثة خمسون بعد المئة نعم الشراب وهاروية
الحميد

Love understands all languages.

Mediterranean proverb

الحب يفهم كل اللغات.

مثل متوسطي

In your love, eternally, I delight.
To your love, I submit.

Ibn Zaydoun (11th century)

بهواك، الدهر، ألهو وبحبيك ادين.

ابن زيدون ـ القرن الحادي عشر

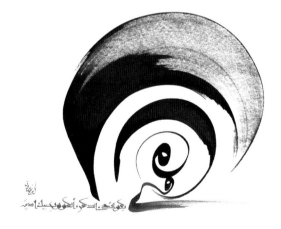

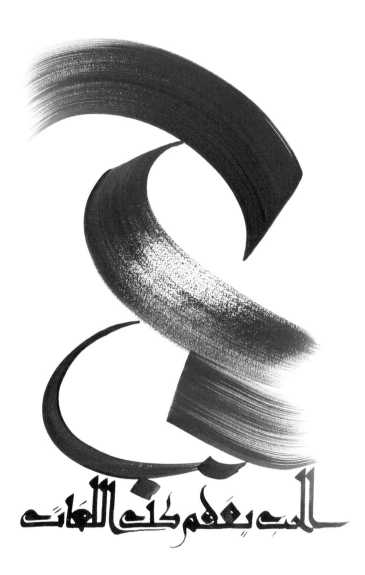

الست يعلم دنك اللهك

For those who love, time is endless. ▷

Mediterranean proverb.

لمن يحب الزمن هو أبدي.

مثل متوسطي

Bow to nothing but love. ▽

René Char (1907–1988)

لا تنحني الا للحب.

رينة شار ـ القرن العشرين

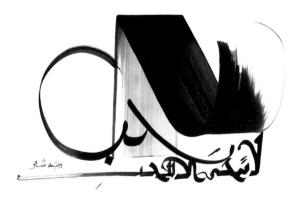

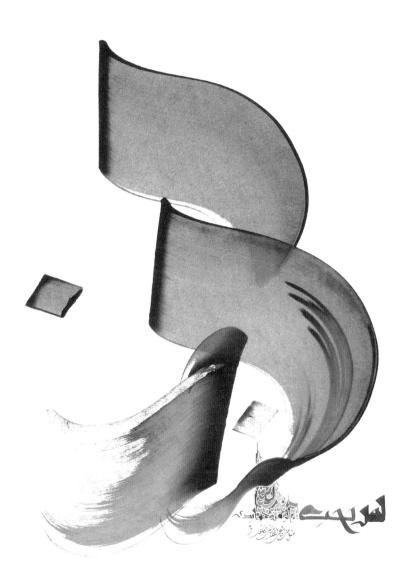

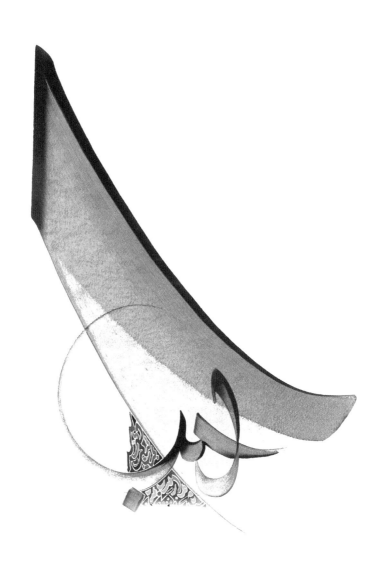